Calligraphy

mad

EAS

A Beginner's

MARGARET SH

Thorso
An Imprint of HarperCollins Publishers

TABLE of CONTENTS

Thorsons
An Imprint of HarperCollins Publishers
77~85 Fulham Palace Road,
Hammersmith, London W6 8JB

First published by Thorsons 1986
10

© 1984 Margaret Shepherd

Margaret Shepherd asserts the moral right to
be identified as the author of this work

A CIP catalogue record for this work
is available from the British Library

ISBN 0 7225 1125 6

Printed in Great Britain by Woolnough Bookbinding,
Irthlingborough, Northamptonshire

Though books may get written in solitude, they are thought up in the middle of things, to fill a need or try out a hunch. So it is with *Calligraphy Made Easy*. The idea for this book popped into existence to help beginners understand & practice lettering And I owe it all to Lisbet and Kirsten, who sat up lettering with me one night at the kitchen table and asked me to write them an easy book. This is it.

THANKS

INTRODUCTION

If you have enjoyed looking at calligraphy but have never tried it before, or if you have attempted to learn but couldn't quite get the hang of it, you are in for a pleasant surprise—calligraphy is easy! It is as much a matter of learning to SEE as it is of learning to DO. The large, detailed illustrations in *Calligraphy Made Easy* make you see how each letter is formed; the carefully programmed trace-and-copy practice helps your eye to teach your hand; & the precision guide lines and slant lines keep any errors from turning into habits. There is even a space under each letter for variations that you or your teacher prefer. And you can evoke a medieval manuscript with the ornate capitals and borders simplified here.

Calligraphy is accessible to anyone who has a little patience and the right kind of pen. Its great depth and variety will challenge your strengths while its innate appeal will compensate for your weaknesses. It employs your entire mind. It rewards almost any effort. It opens your eyes to the beauty of letters around you. *Calligraphy Made Easy* will help you learn about the pen, about letters, about seeing—about yourself.

MATERIALS

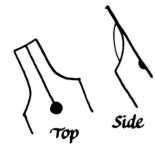

Top Side

Fountain pen

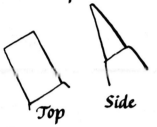

Top Side

Fiber marker

CHISEL-TIPPED PENS
SUITABLE FOR THIS BOOK:

Shaeffer "No-Nonsense"
 cartridge pen (Broad)
Osmiroid (B4)
Platignum (B4)

Sanford Calligraphic Pen
Marvy Marker (small)
Design Art Chisel Point
 Marker
Chiz'l pen
Niji Stylist Calligraphy
 Marker (narrow, 2.0)

To remove
a page

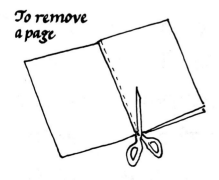

Choose a pen that has a calligraphy point, a wide, flat, chisel-like nib. It must make thick and thin strokes. A fine point or a fat point will not give the correct contrast between thick and thin that gives the letters their distinctive look.

You will use your pen to write directly in this book (unless you want to keep the pages unmarked by using tracing paper). Make sure the pen you buy is ⅛" to 3/16" wide, so that the letters you make will look like the examples and fit the guidelines provided. You can draw extra guidelines in pencil on typing or copier paper, if you like, or use a 3/8" blue-lined notebook pad.

If after you fill in one of the bordered sheets you want to remove it from the book, make your cut about ¼" away from the binding to prevent the page attached to it from falling out of the other side of the book.

HOLDING THE PEN

Hold the pen loosely and comfortably, so that the end aims up your forearm to your shoulder.* Do not try to alter your customary writing posture. Now compare your hand position with the one shown below until you have it right; then trace over the exercise strokes to get the feel of writing with your new pen.

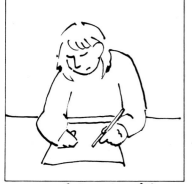

Right-hand position

Left-hand position; paper is turned to compensate angle.

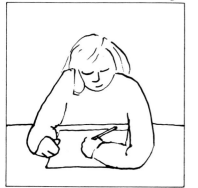

Left-hand alternate position; use only if you are used to it.

Wrong left-hand position; pen angle will be backward.

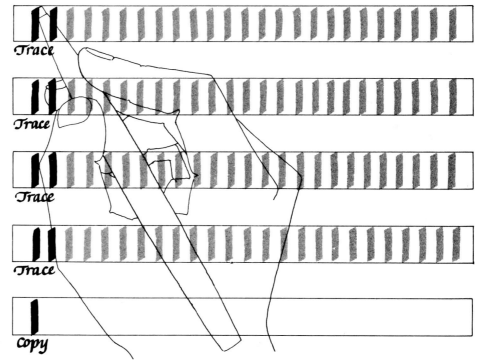

Trace

Trace

Trace

Trace

Copy

Notice that the wide-pointed pen nib makes a stroke that looks different from the pencil, marker, or ballpoint pen you may be accustomed to. The calligraphy

* ABOVE: RIGHT-HAND, & CORRECT & INCORRECT LEFT-HAND POSITIONS.

pen stroke has width as well as length; it takes up space; it has a top end and a bottom end as well as two edges.

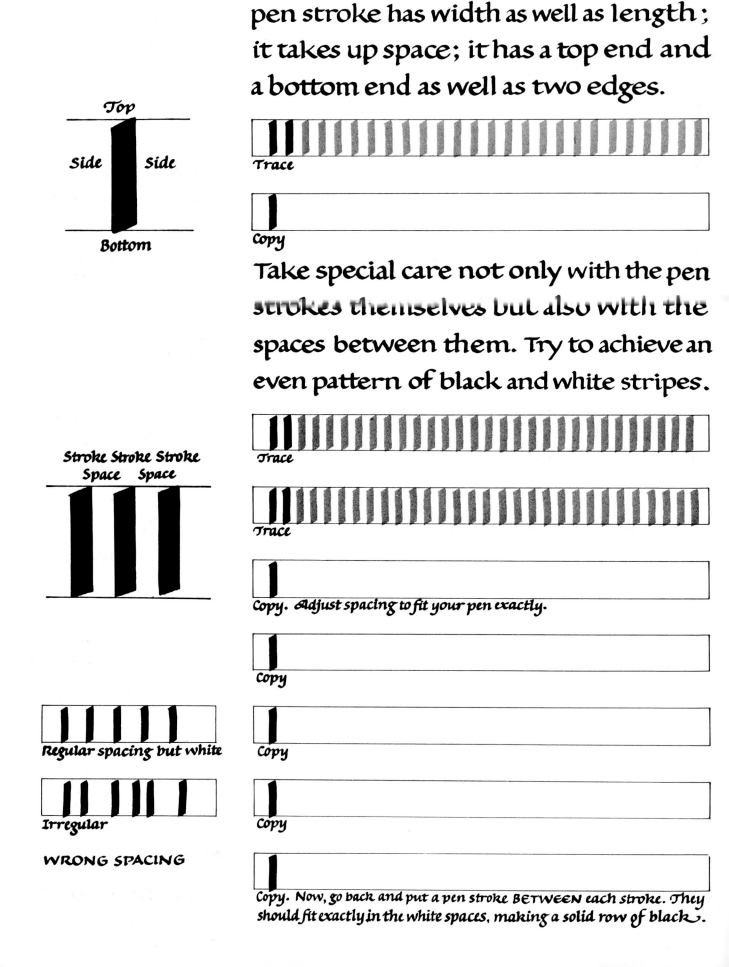

Take special care not only with the pen strokes themselves but also with the spaces between them. Try to achieve an even pattern of black and white stripes.

Copy. Now, go back and put a pen stroke BETWEEN each stroke. They should fit exactly in the white spaces, making a solid row of black.

Be sure your pen strokes are upright as well as parallel. Don't let them lean over.

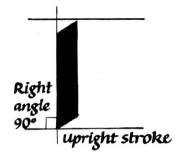

Right angle 90°
upright stroke

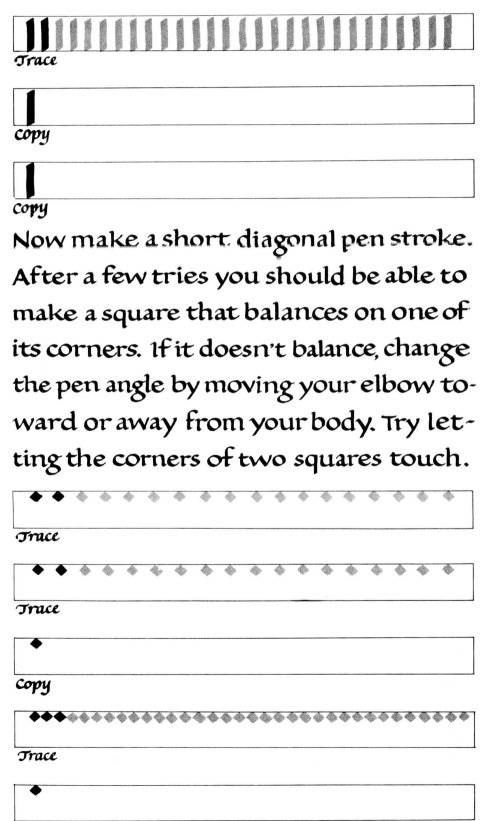

Trace

Copy

Copy

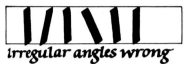
Irregular angles wrong

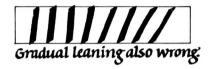
Gradual leaning also wrong

Now make a short diagonal pen stroke. After a few tries you should be able to make a square that balances on one of its corners. If it doesn't balance, change the pen angle by moving your elbow toward or away from your body. Try letting the corners of two squares touch.

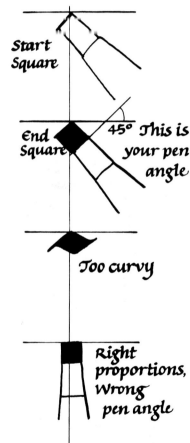

Start Square

End Square

45° This is your pen angle

Too curvy

Right proportions, Wrong pen angle

Wrong proportions Right pen angle

Trace

Trace

Copy

Trace

Copy

Now—you are ready for Gothic.

THE GOTHIC ALPHABET

Gothic letters come from the Middle Ages (A.D. 1100 ~1400). They were used by monks to write copies of religious texts from which to sing, read, preach, pray, and study. Though they look very intricate, in practice Gothic letters prove to be much simpler than any other calligraphy alphabet because they are all made from three fundamental strokes and one basic letter shape. Two of these strokes you know already from the last chapter; now just fit them together.

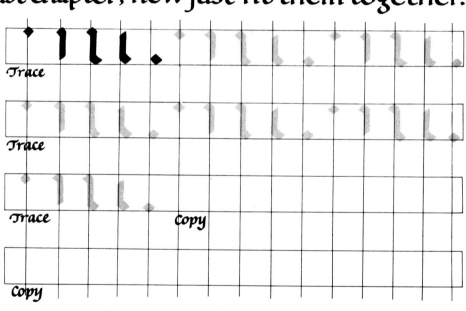

Trace

Trace

Trace Copy

Copy

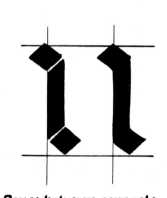

Pause between separate strokes but do not lift pen.

The third stroke is the horizontal bar.

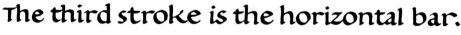
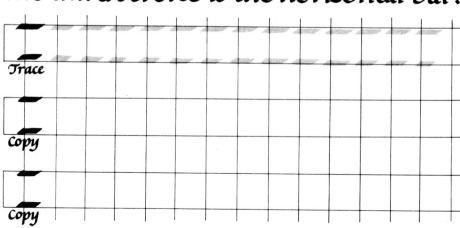

Trace

Copy

Copy

Triangle

Triangle

Length will vary in some letters, but position at left of letter remains constant.

By arranging these three strokes in different combinations, you can construct all 26 Gothic letters.

abcdefghijklmnopqrstuvwxyz

Pay attention to the basic shape of the O. The square stroke just touches the guide line. If you let the straight stroke begin by touching the guidelines, you will not have enough room for the square stroke.

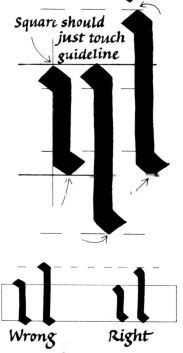

Square should just touch guideline

Trace Copy

Trace Copy

Trace Copy

Wrong Right

POSITIONING LETTERS ON GUIDELINES

Remember your pen practice with a row of even stripes? Now you can turn them into Gothic letters, using squares.

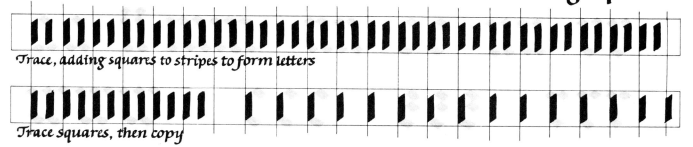

Trace, adding squares to stripes to form letters

Trace squares, then copy

The rest of the letters can be put together with shorter or longer straight strokes, squares, and horizontal bars, as detailed in the next 13 pages.

Trace

a

Trace
Trace
Trace and copy
Trace and copy
Copy
Copy

a a

Alternate
letter forms

b

Trace
Trace
Trace and copy
Trace and copy
Copy
Copy

Alternate
letter forms

A thin line here will help balance the letter.

Trace

Trace

Trace and copy

Trace and copy

Copy

Copy

Alternate letter forms

This stroke should look like an extension of this square.

Trace

Trace

Trace and copy

Trace and copy

Copy

Copy

Alternate letter forms

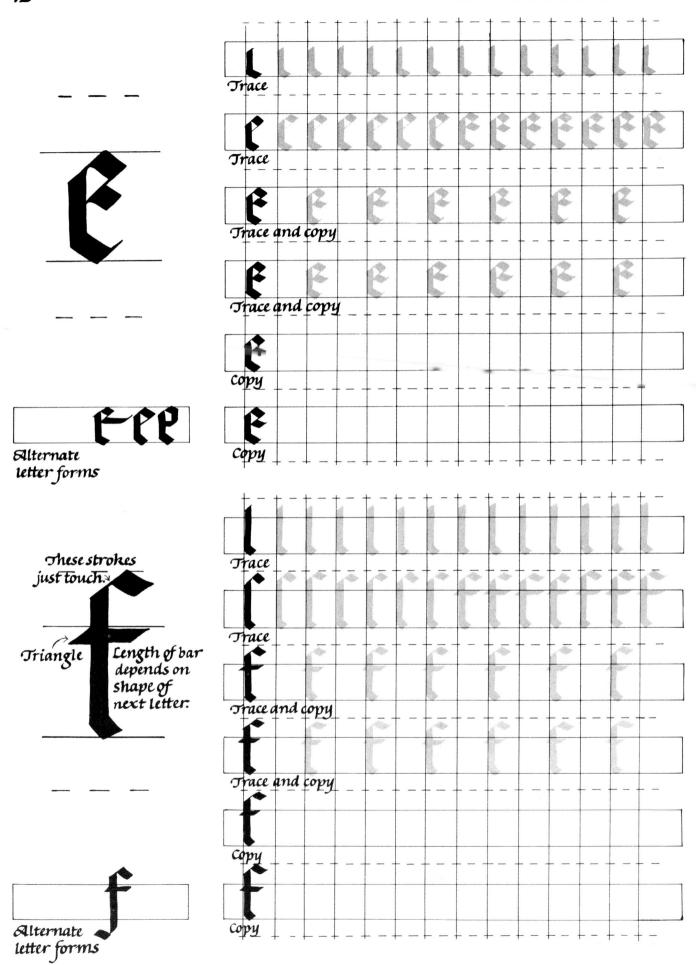

Trace

Trace

Trace and copy

Trace and copy

Copy

Copy

Alternate
letter forms

These strokes
just touch

Triangle Length of bar
depends on
shape of
next letter.

Trace

Trace

Trace and copy

Trace and copy

Copy

Copy

Alternate
letter forms

Trace

Trace

Trace and copy

Trace and copy

Copy

Copy

Triangle

Descender
does not reach guideline.

Alternate
letter forms

Trace

Trace

Trace and copy

Trace and copy

Copy

Copy

Alternate
letter forms

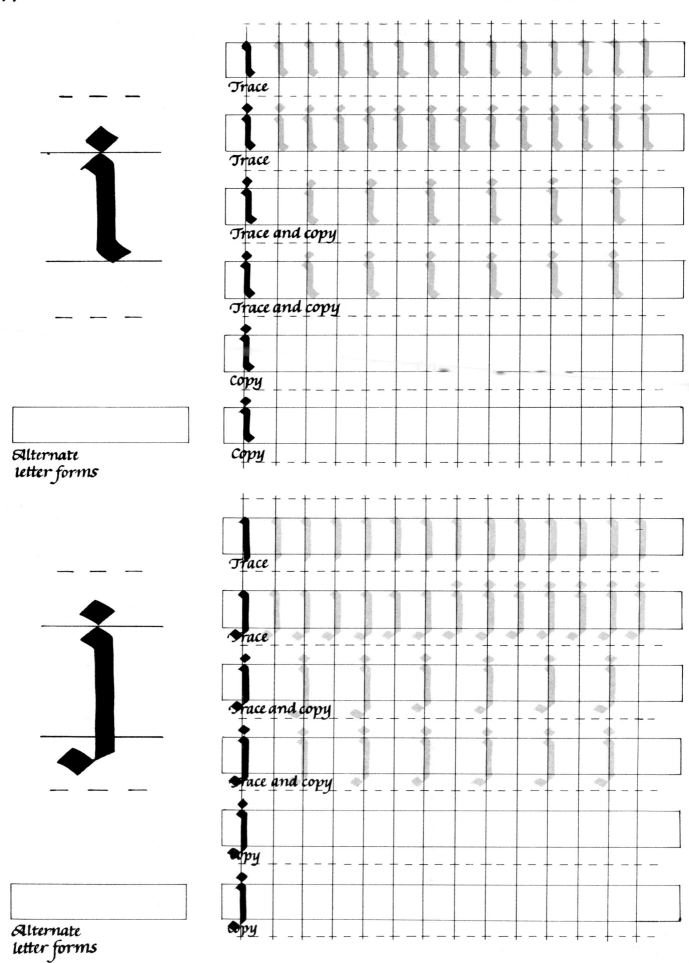

Alternate
letter forms

Trace

Trace

Trace and copy

Trace and copy

Copy

Copy

Trace

Trace

Trace and copy

Trace and copy

Copy

Copy

Alternate
letter forms

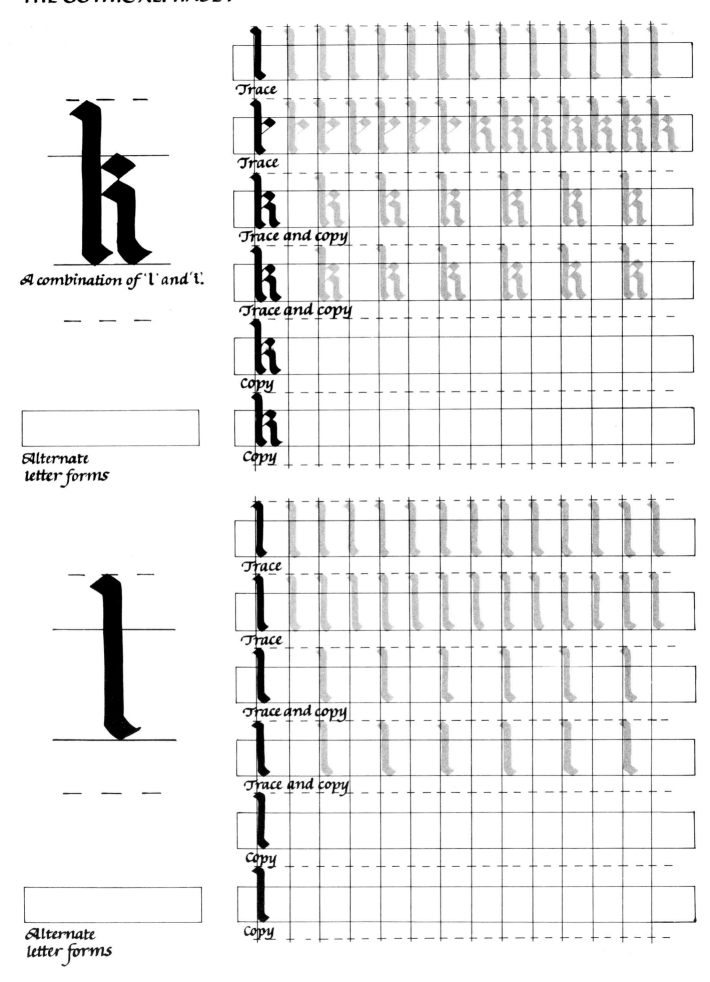

A combination of 'l' and 'l'.

Alternate
letter forms

Alternate
letter forms

Trace

Trace

Trace and copy

Trace and copy

Copy

Copy

l
Trace

n
Trace

m
Trace and copy

m
Trace and copy

m
Copy

m
Copy

m

Alternate
letter forms

l
Trace

n
Trace

n
Trace and copy

n
Trace and copy

n
Copy

n
Copy

n

Alternate
letter forms

o

Trace

Trace

Trace and copy

Trace and copy

Copy

Copy

Alternate
letter forms

l

Trace

p

Trace

Trace and copy

Trace and copy

Copy

Copy

Triangle

ppp

Alternate
letter forms

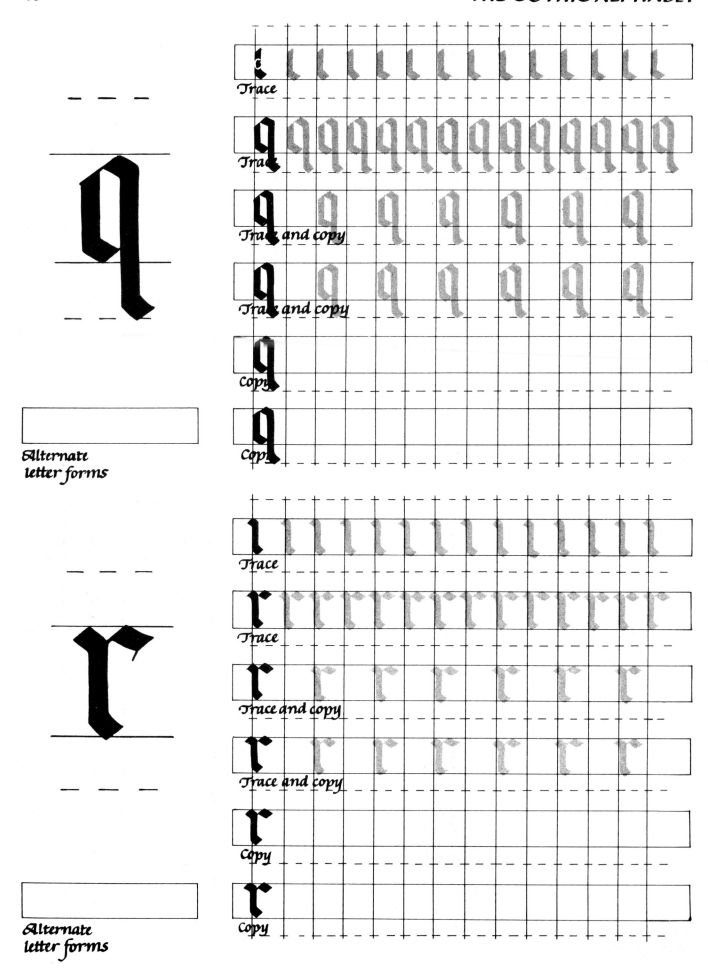

q

Trace

Trace

Trace and copy

Trace and copy

Copy

Copy

Alternate
letter forms

r

Trace

Trace

Trace and copy

Trace and copy

Copy

Copy

Alternate
letter forms

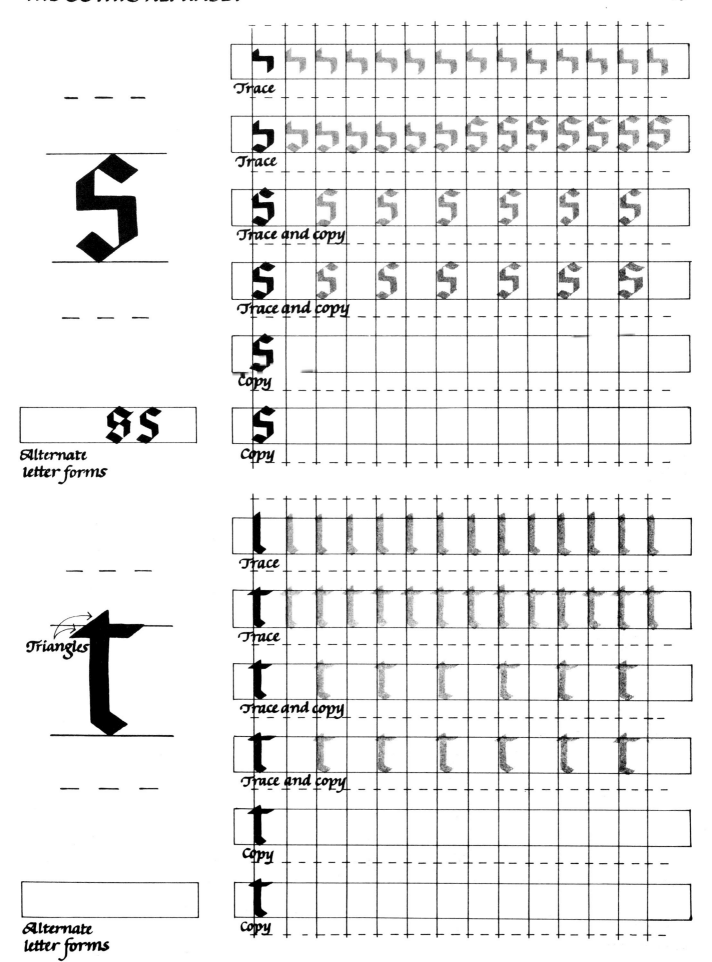

Trace

Trace

Trace and copy

Trace and copy

Copy

Copy

Alternate
letter forms

Triangles

Trace

Trace

Trace and copy

Trace and copy

Copy

Copy

Alternate
letter forms

u

This stroke is all that
distinguishes 'u' from 'v.'

Alternate
letter forms

Trace

Trace

Trace and copy

Trace and copy

Copy

Copy

v

Alternate
letter forms

Trace

Trace

Trace and copy

Trace and copy

Copy

Copy

Trace

Trace

Trace and copy

Trace and copy

Copy

Copy

Alternate
letter forms

Thin
lines
balance
letter.

Bar
equals
two
triangles

Trace

Trace

Trace and copy

Trace and copy

Copy

Copy

Alternate
letter forms

y

Trace

Trace

Trace and copy

Trace and copy

Copy

Copy

Alternate
letter forms

z

Bar

Square

Bar

Trace

Trace

Trace and copy

Trace and copy

Copy

Copy

Alternate
letter forms

Now that you are acquainted with all the Gothic letters, you can put them together to form words. Notice how some letter combinations are easy to space; they align themselves evenly to make black and white stripes.

minimum william

Trace

Copy

Regular letter space.

Other letters break the striped pattern with an occasional mid-stroke, but conform outwardly to the Gothic shape.

ask kiss saki task

Trace

Copy

Half-regular letter space

A few letters, however, have such irregular outlines that you have to position them by eye, estimating the VISUAL SPACE (not the distance) between them.

racer arc cratered

Trace

Copy

Irregular letter space

crazed exit free aft

Trace

Copy

Irregular letter space

The next step after letter spacing is word spacing. Leave about the equivalent of an "o" between words.

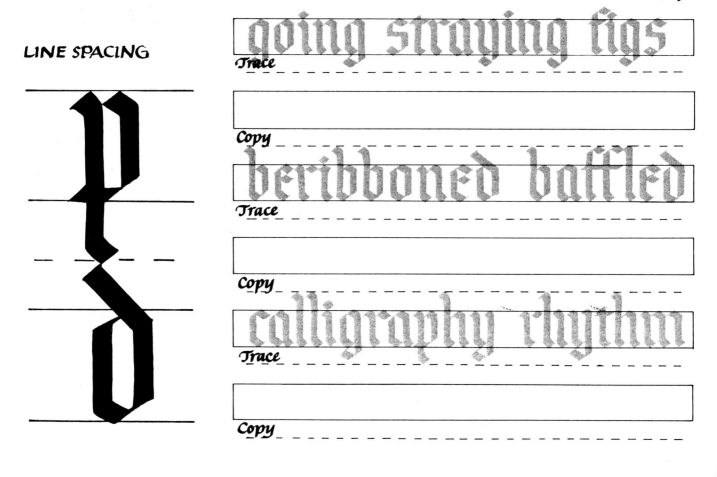

WORD SPACING

Trace

Copy

Trace

Copy

As you progress toward writing a whole sentence, watch a new kind of space taking shape between lines of letters. Take care not to let the ascenders and descenders overlap.

LINE SPACING

Trace

Copy

Trace

Copy

Trace

Copy

Now all you need is to practice the hundreds of possible letter combinations, by lettering out short quotations. start with the guidelines provided here and on page 27, 29, 31, 32, 33, & 34.

pack my box
with five dozen
lacquer jugs

the quick brown
fox jumps over
the lazy dog

angry gods just
flocked up to
quiz and vex him

abercrombie and
fitch leave ex-judge's
equipment wick

abcdefgh
ijklmnopqr
stuvwxyz

CAPITAL LETTERS

An important element of any hand-lettered page is the choice of capitals. You will need two basic kinds: small and medium pen capitals to begin sentences and proper nouns, and medium and large drawn capitals to begin paragraphs and whole pages. Here is a set of pen capitals.

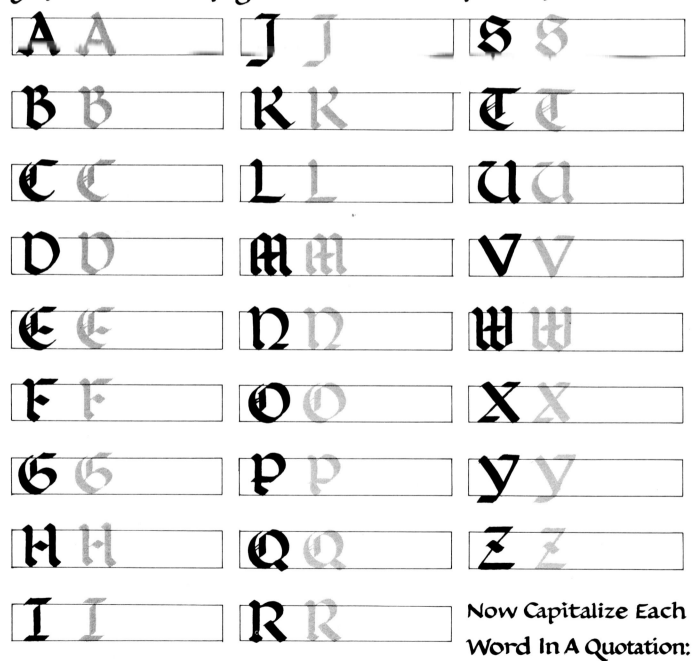

Now Capitalize Each Word In A Quotation:

Of all those arts in which the wise excel, nature's chief masterpiece is writing well.

THUMBNAIL SKETCH

Use spaces below to plan your calligraphy in pencil.

Lettering a quotation involves placing it on the page in a visually balanced, appealing, and meaningful layout. BEFORE YOU START, make a little rough draft (artists call this a "thumbnail sketch"). Pencil in how the words will fall and where each new line will begin. Leave extra spaces for capitals. Visualize your margins. Try one or two alternative approaches.

Go confidently in the direction of your dreams! Live the life you've imagined!

Letters mingle souls

A drawn capital offers an unlimited choice of size, style, and pictorial material. Use sparingly—one or two per page—and make sure the initial suits both the meaning and the layout of the text.

Draw letter with flat part of calligraphy pen, then add detail with edge of nib or a thin-pointed pen. Combine background and decoration from several letters for a richer effect; omit all but the letter outline for simplicity.

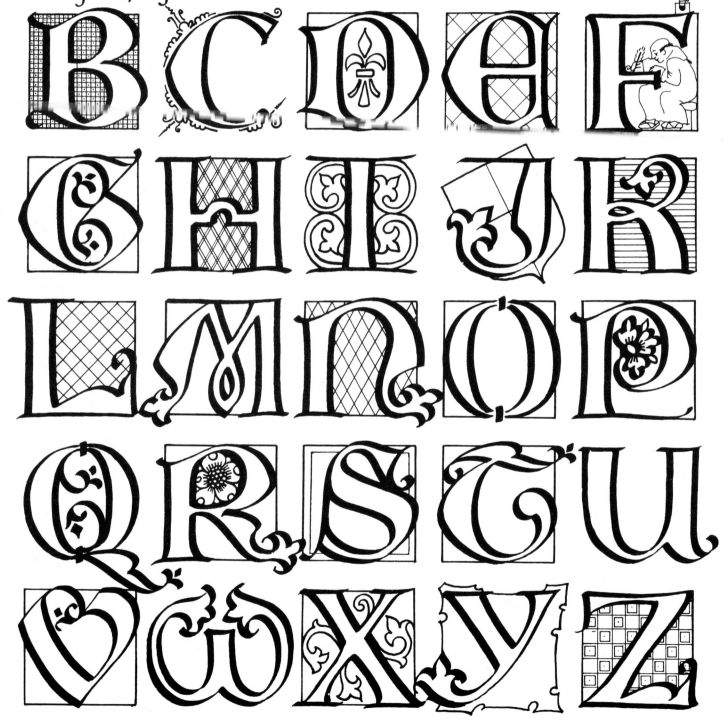

You are cordially
invited:

R.S.V.P.

THE ITALIC ALPHABET

Italic letters originated in the Italian Renaissance (A.D. 1400~1600), answering the need for a faster, clearer, less formal letter than Gothic. While they resemble Gothic slightly in the repeating pattern of parallel strokes, Italic letters are almost all based on a completely new shape.

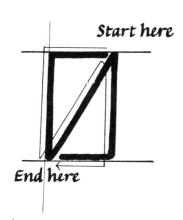

Start here

End here

The correct direction and sequence of strokes are more important at first than graceful curves or thick and thin pen lines.

First, put down your calligraphy pen; use a pencil, marker, or ball~point, instead, to see and analyze the underlying structural logic of the Italic letter.

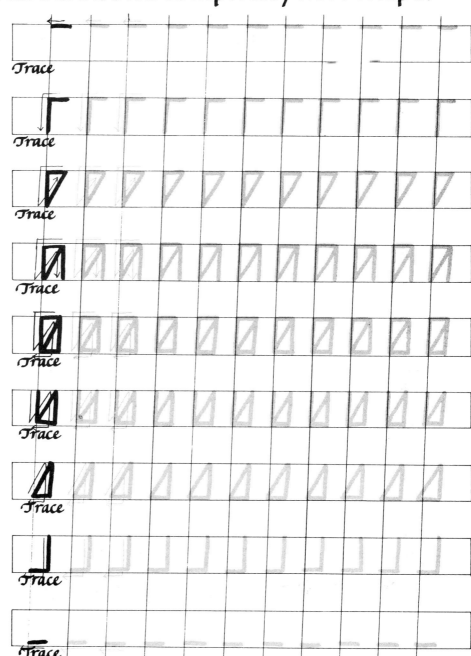

Trace

Now letter the same basic shape with a calligraphy pen until it feels comfortable.

Trace

Trace and copy

Copy

Copy

If you are using a fountain pen, you may have a little trouble pushing strokes #1 and #5. Slow down; be sure your pen is full of ink; keep the nib flat on the page; and if all else fails, lift the pen before strokes #1 and #5 to pull rather than push them.

Omit the last stroke. Round off corners.

Trace

Trace

Note tri~ angular space here.

Trace and copy

Trace and copy

Copy

Copy

Copy

Then practice it without the first stroke. Round off corners.

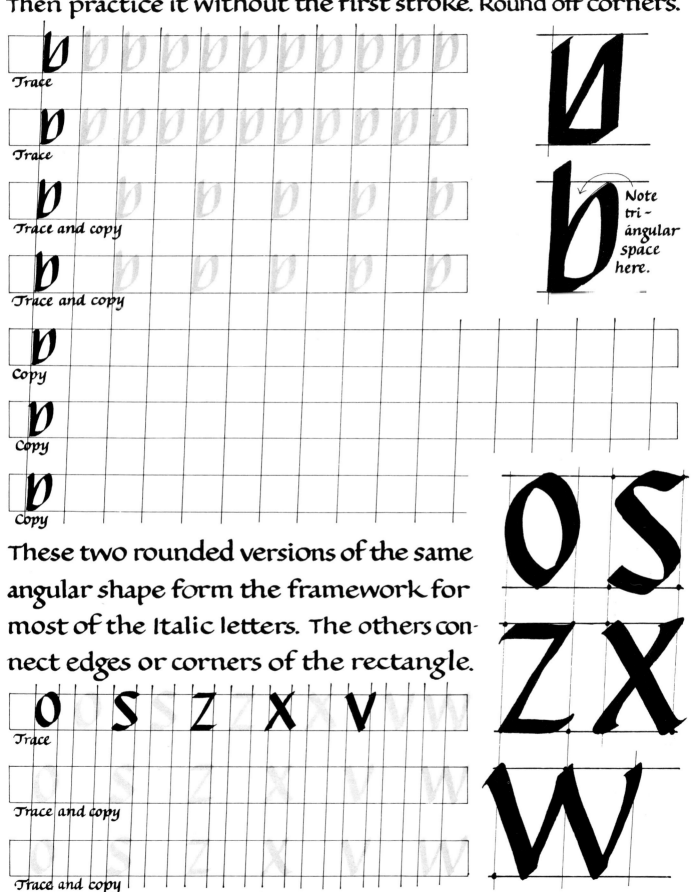

Trace

Trace

Trace and copy

Trace and copy

Copy

Copy

Copy

Note tri-angular space here.

These two rounded versions of the same angular shape form the framework for most of the Italic letters. The others connect edges or corners of the rectangle.

O S Z X V

Trace

Trace and copy

Trace and copy

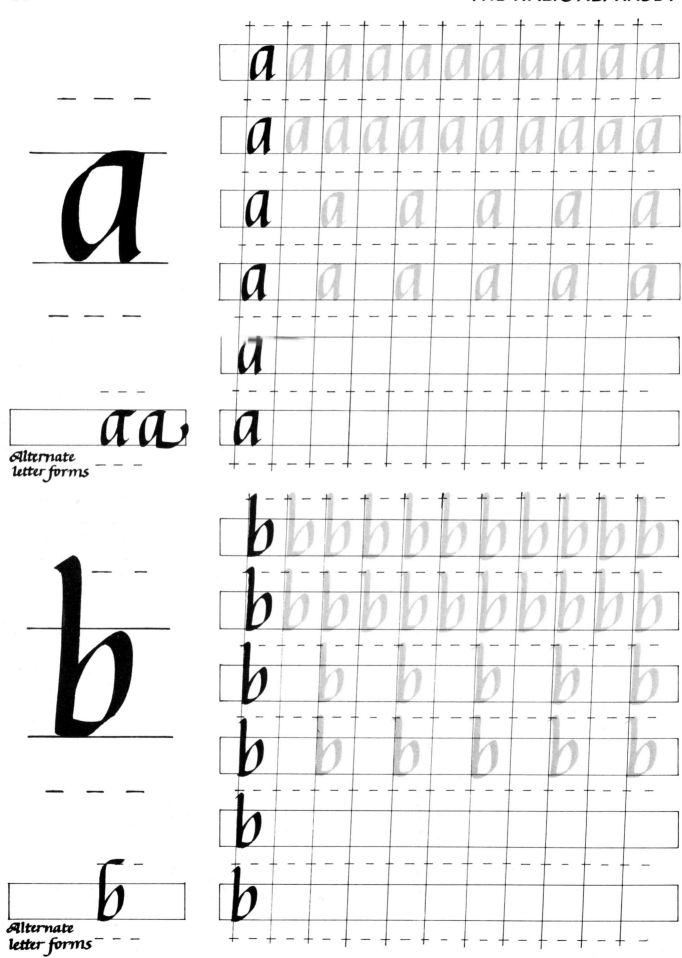

Alternate letter forms

Alternate letter forms

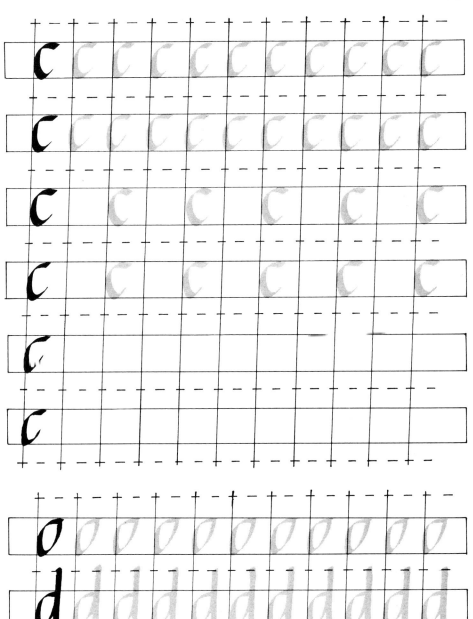

Can be rounded off like 'o'

C

Alternate
letter forms

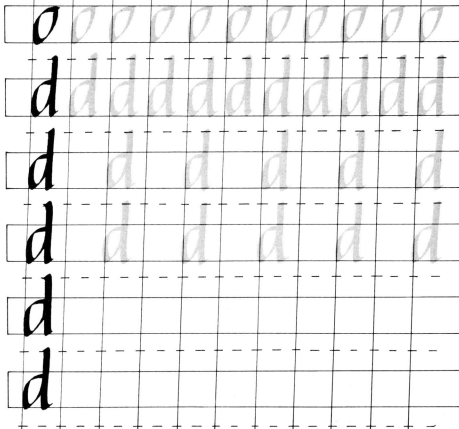

Alternate
letter forms

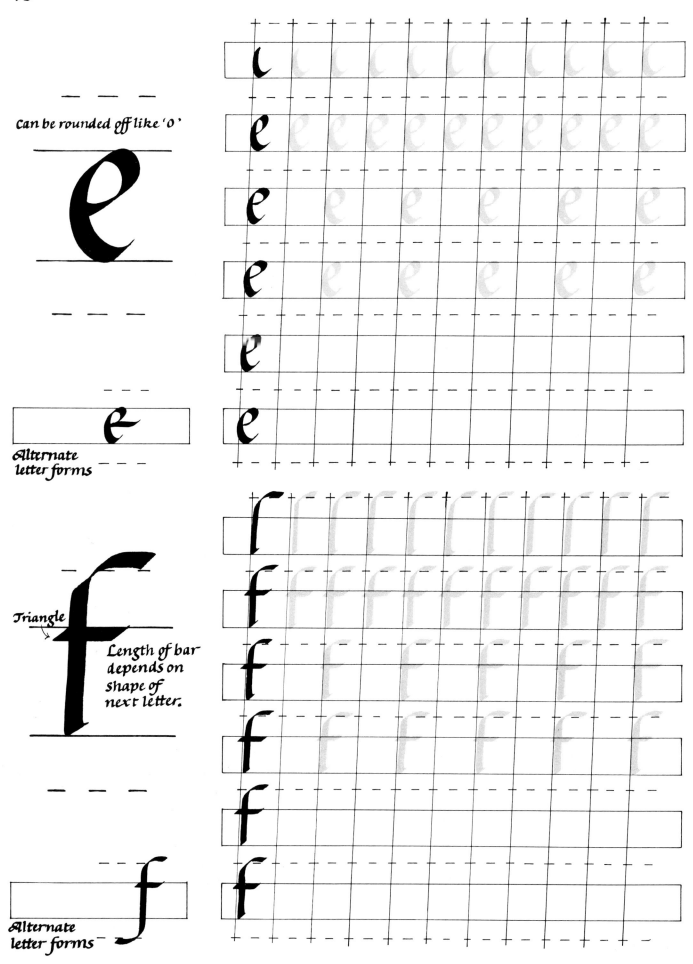

Can be rounded off like 'o'

e

*Alternate
letter forms*

Triangle

Length of bar
depends on
shape of
next letter.

*Alternate
letter forms*

A flattened square

Alternate letter forms

A flattened square

Alternate letter forms

g

Alternate
letter forms

h

Alternate
letter forms

Alternate
letter forms

Alternate
letter forms

m

m

Alternate
letter forms

n

n

Alternate
letter forms

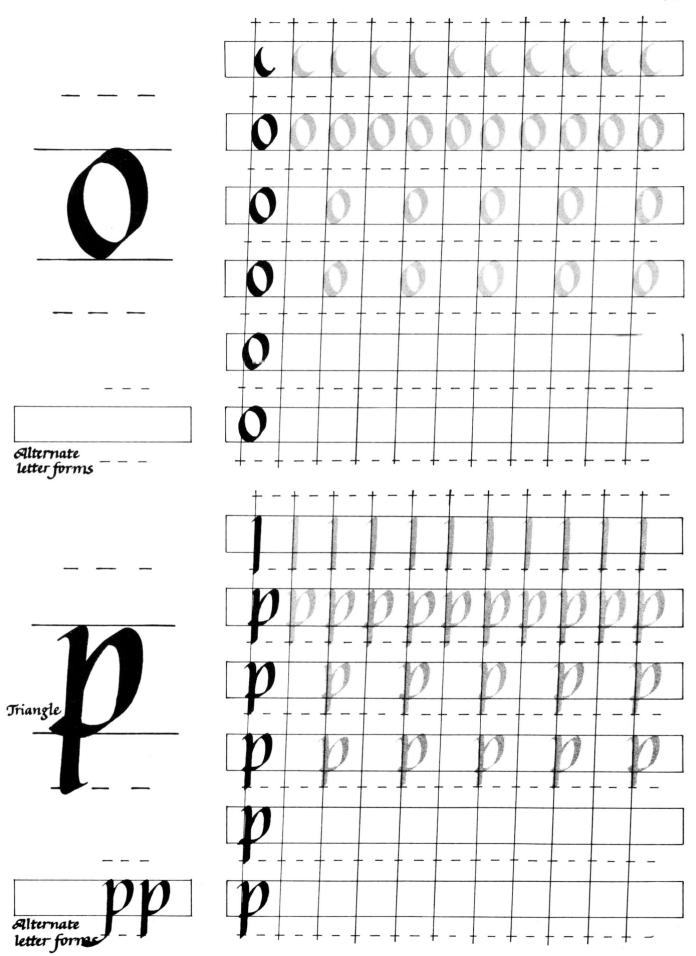

O

Alternate letter forms

Triangle p

pp

Alternate letter forms

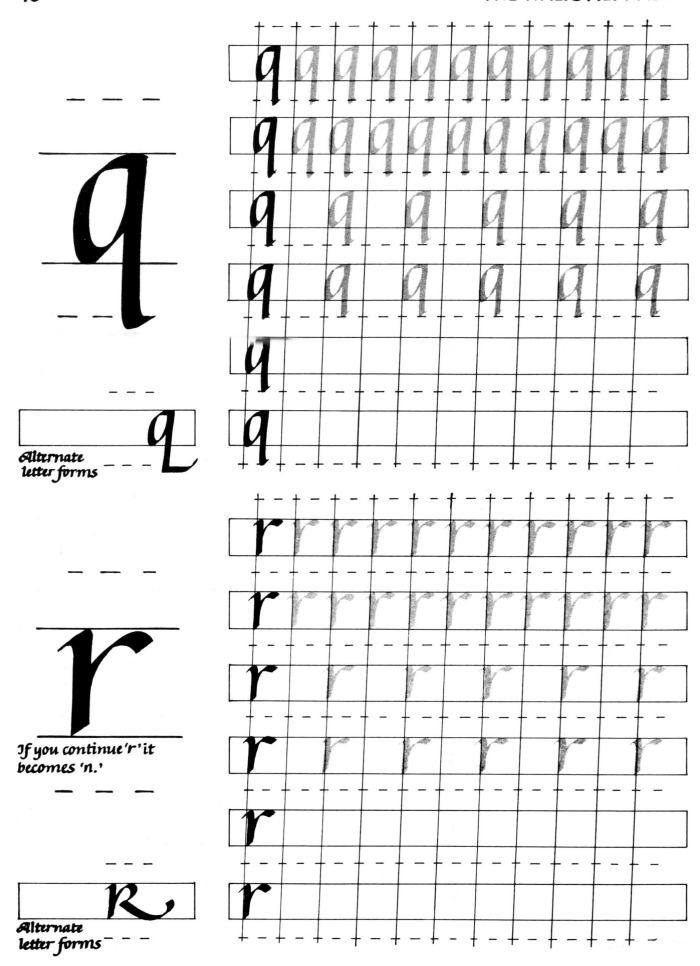

q

Alternate letter forms

r

If you continue 'r' it becomes 'n.'

Alternate letter forms

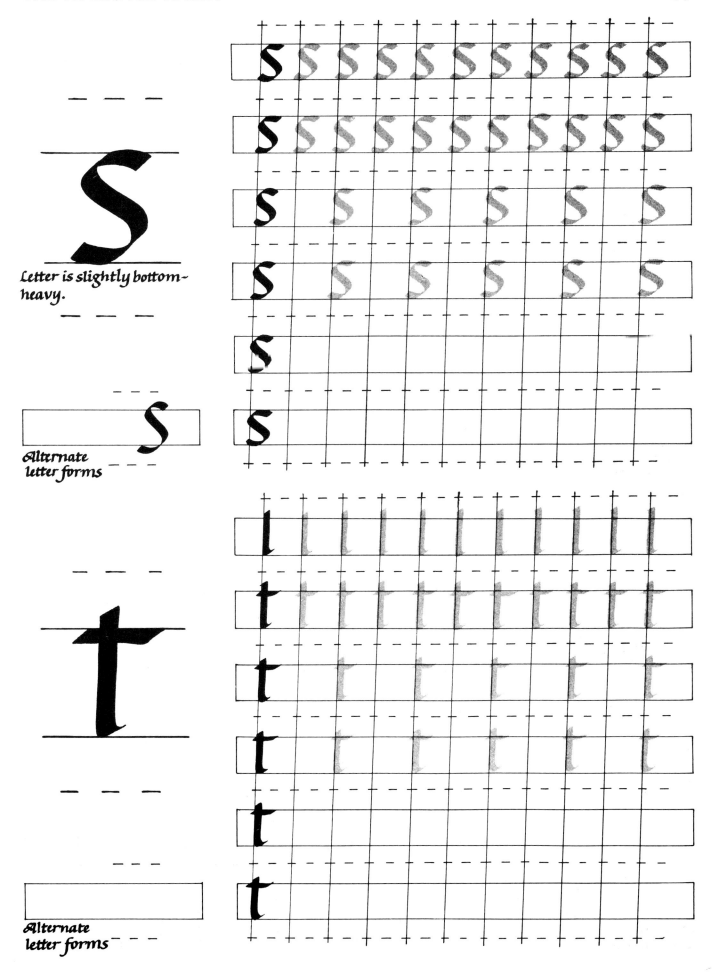

Letter is slightly bottom-
heavy.

Alternate
letter forms

Alternate
letter forms

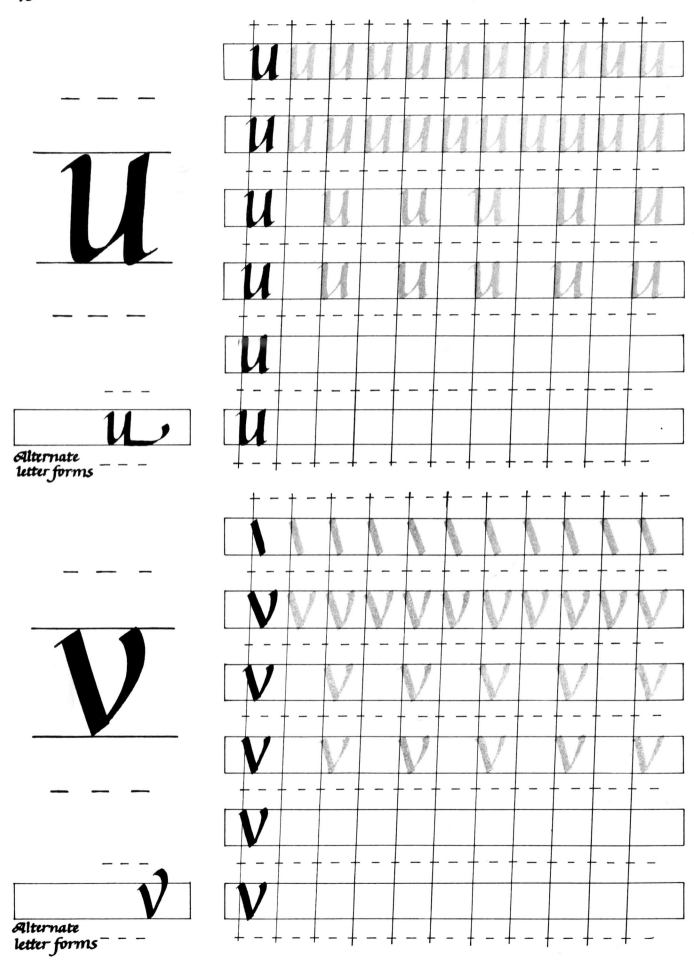

Alternate
letter forms

Alternate
letter forms

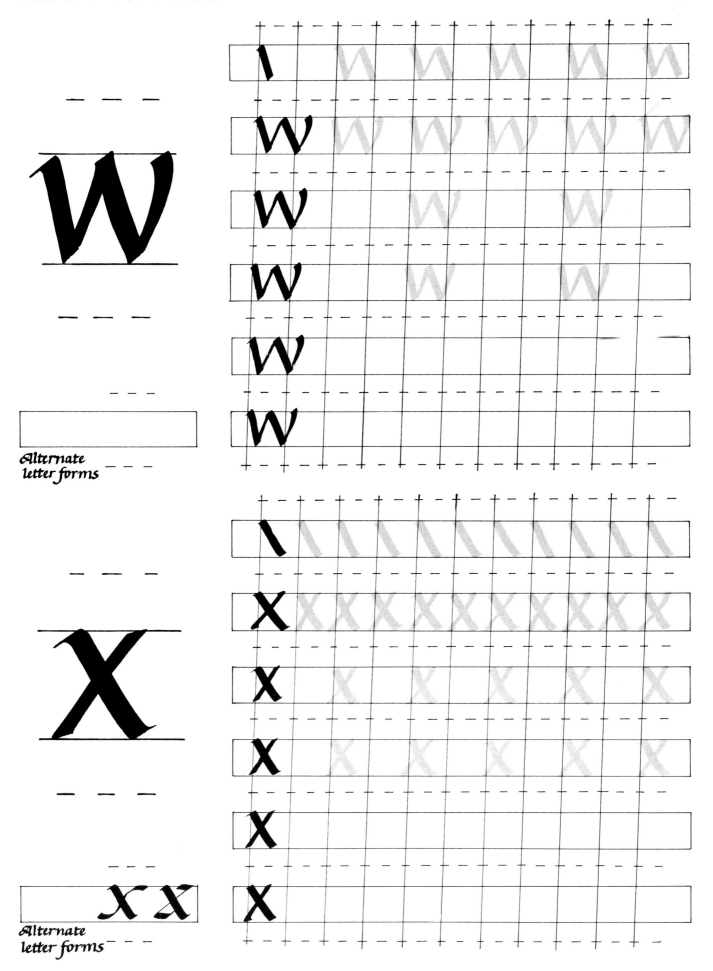

Alternate
letter forms

Alternate
letter forms

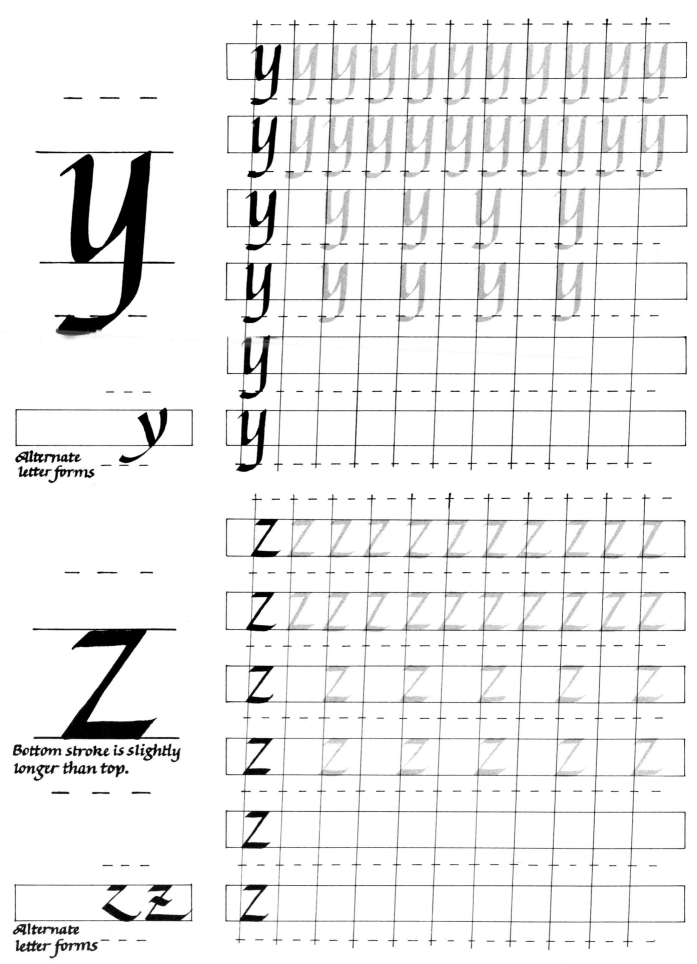

Alternate letter forms

Bottom stroke is slightly longer than top.

Alternate letter forms

When you write Italic letters slowly and carefully in formal quotations of tradi-tional design, lift the pen up after every letter before starting the next one.

FORMAL JOINS

When you write Italic more quickly in contemporary designs or casual hand-writing, connect some of the letters to each other without lifting the pen. Try some of these joins, and experiment with other possibilities until you have decid-ed which combinations will work for you.

INFORMAL JOINS

Some joins seem clearly unusable. Try them anyway.

Whether you choose the deliberate formal joins or the more informal spontaneous informal joins, Italic letters demand as much attention to letter spacing as Gothic letters do. Many letter groups will produce the same regular, striped effect.

na

Regular patterns

Trace and copy

Trace and copy

Trace and copy

minim

Trace and copy

allay

Trace and copy

os

Irregular spaces

A few odd letters create spaces around them that must be estimated visually to correspond to the regular spaces.

minute creased oozed

Trace

Copy

awkward vex ox weft

Trace

Copy

Use the space below to letter your name in Italic. Do not worry about capitals yet (you will get to them on page 54); just concentrate on forming and spacing the letters in your name. Write it over and over. Try some alternate letters, different kinds of spacing, and every variety of join.

Italic capitals are similar in function to Gothic capitals, except that you can capitalize whole words or even sentences without boggling the reader. Try a poem in the space provided on page 55, capitalizing the first letter, line, or word, to suit text and meaning.

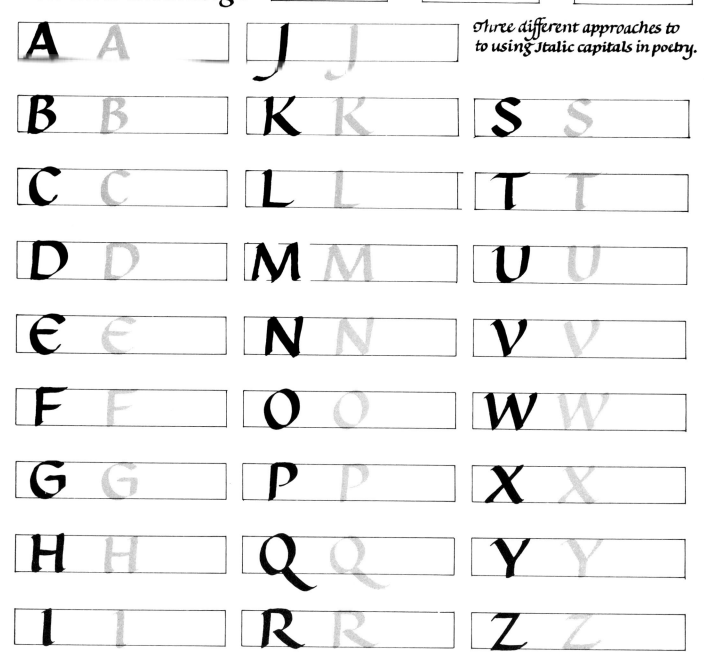

My mind to me a kingdom is
Such present joys therein I find,
That it excels all other bliss
That world affords or grows by kind.
Though much I want
 which most would have,
Yet still my mind forbids to crave.

MY MIND
to me a kingdom is
Such present joys therein I find,
That it excels all other bliss
That world affords or grows by kind.
Though much I want
 which most would have,
Yet still my mind forbids to crave.

MY MIND TO ME
A KINGDOM IS,
Such present joys therein I find,
That it excels all other bliss
That world affords or grows by kind.
Though much I want
 which most would have,
Yet still my mind forbids to crave.

Three different approaches to using Italic capitals in poetry.

A J S
B K T
C L U
D M V
E N W
F O X
G P Y
H Q Z
I R

Have fun with swash capitals

A
B
C
D
E
F
G
H
I
J
K
L

M
N
P
Q
R
S
T
U
V
W
X
Y
Z

Try your initials in the spaces opposite. Fold in quarters for notepaper, greeting card, or valentine.

Numerals to harmonize with the Italic alphabet must imitate the ascenders and descenders of the small letters.

Trace

Copy

Now try some numeral combinations. Note similarities.

Trace

Copy

Letter your name, address, & postcode, as if on an envelope.

Now re-letter your name and address to try some other possible layouts for your own letterhead stationery.

Name and Surname
Number and Street
City. County and postcode
Telephone

Name and Surname
Number and Street
City. County and postcode
Telephone

𝒩𝒮
Name and Surname Number and Street
City. County and postcode
Telephone

Name and Surname
Name and surname, Number and Street, City, County and postcode
Telephone

Choose one that not only fits the letters visually but also represents your personality. You can do each sheet by hand; or else letter one copy very neatly in black on white, and take it to a printer for photo-offset reproduction.

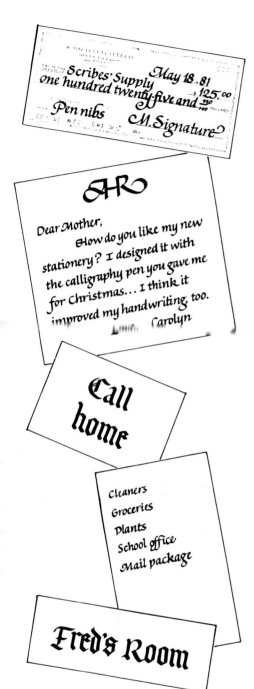

Now that you have met—and perhaps mastered!—the fundamentals of Gothic and Italic calligraphy, you are ready to employ your new abilities in a wide range of artistic projects. All you need is practice. Use calligraphy whenever you can; not just for the fun of seeing your grocery lists, class notes, checkbook, personal correspondence and telephone messages assume a new elegance, but also for the stimulation of finding formerly unnoticed roles for traditional letters in modern life.

To complete your *Calligraphy Made Easy* workbook, you still have one more line to fill in. Give yourself a real graduation diploma by putting your name (first, middle, & last) in the guidelines. A line is provided also for the date, and for the signature of a teacher if you have had the help of one. Remember that, like all diplomas, it is given at "commencement," and so represents not the ending but the beginning of a lifelong interest in letters.

This is to certify that

has successfully completed

all the exercises

in Calligraphy Made Easy

and has mastered the fundamentals

of

Gothic and Italic

calligraphy

Margaret Shepherd

OTHER BOOKS
BY MARGARET SHEPHERD

BORDERS FOR CALLIGRAPHY
How to Design a Decorated Page

CALLIGRAPHY PROJECTS FOR PLEASURE AND PROFIT

CAPITALS FOR CALLIGRAPHY
A Sourcebook of Decorative Letters

LEARNING CALLIGRAPHY
A Book of Lettering, Design, and History